Posters

A Century of Summer Exhibitions
at the Royal Academy of Arts

Royal Academy of Arts

British Library Cataloguing-in-
Publication Data A catalogue
record for this book is available
from the British Library

ISBN 978-1-910350-04-1

Distributed outside the United
States and Canada by Thames
& Hudson Ltd, London

Distributed in the United
States and Canada by Harry
N. Abrams, Inc., New York

Royal Academy Publications
Beatrice Gullström
Alison Hissey
Carola Krueger
Simon Murphy
Peter Sawbridge
Nick Tite

Book design: Design by S-T
Photography of the posters:
 Prudence Cuming Associates Ltd
Colour origination and printing in
 Wales by Gomer Press

Acknowledgments
RA Publications would like to thank
Mark Pomeroy of the RA Archive.

Contents

Indulging in Publicity 6

Mark Pomeroy

The Posters

Notes on the Posters 89

Mark Pomeroy

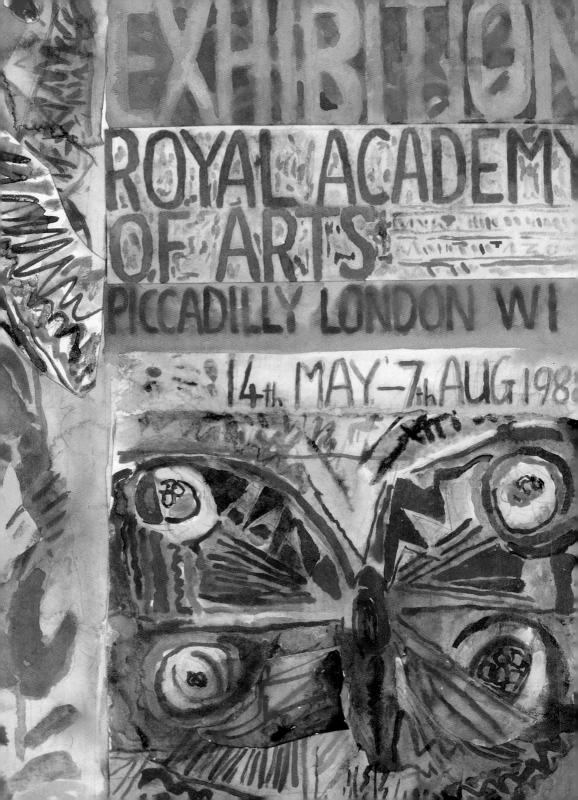

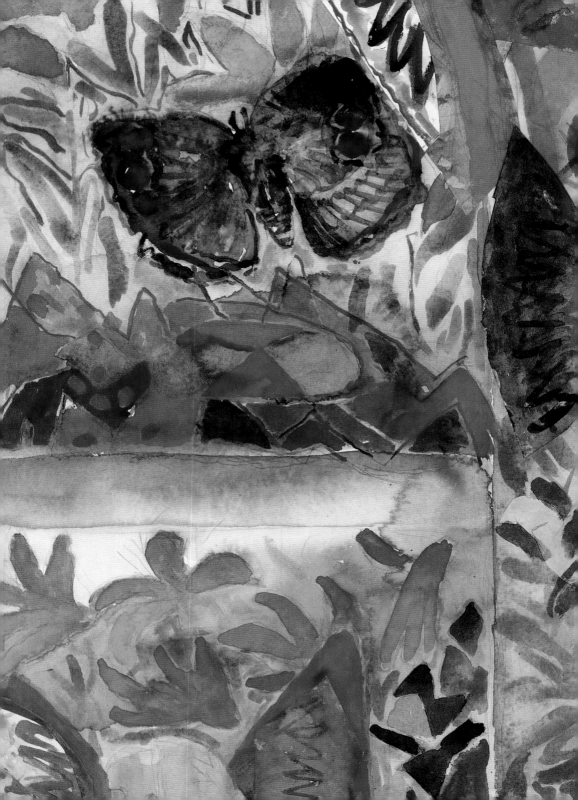

Indulging in Publicity

Mark Pomeroy

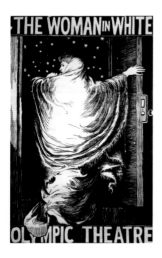

Woodcut poster for the stage version of Wilkie Collins's *The Woman in White*, after an original design by Frederick Walker ARA in gouache on paper, 1871.

Frequent visitors to the capital may have noted a change to the familiar confines of the London Underground. The posters are slowly disappearing. Beside escalators small screens now show brief, muted animations representing the cutting edge of modern urban marketing. Not for the first time, the printed graphic poster finds itself challenged by a new technology and is being nudged towards the margins along with other supposedly antiquated formats, such as the printed book.

Some commentators characterised the poster as a form in decline from almost the day of its inception. But many will pause and look back with regret; artists most certainly, as their relationship with posters and with poster designers has resulted in a fertile seam of creativity that spans the history of modern art. The poster has been renewed by each succeeding generation of artists to become an essential part of modern visual language. Anyone seeking to attract the public eye does so, in part, through the use of posters.

After an extended (one might even say grudging) courtship, the Royal Academy embraced poster design in its own inimitable way. This book is a celebration of the Academy's relationship with the poster, focusing particularly on its most creative expression, the promotion of the Summer Exhibition.

Although France dominated the early history of poster design Britain developed a distinct and vigorous poster culture. The Associate Royal Academician Frederick Walker is widely credited with having produced the first artist-designed advertisement in Britain, with his 1871 design for the Olympic Theatre's production of Wilkie Collins's *The Woman in White*. The impact of this poster was immense and it encouraged the belief that the medium could support real artistic expression.

Nineteenth-century periodicals such as the *Art Journal* and the *Magazine of Art* printed essays that agonised over the extent to which posters could be regarded as fine art. Wiser heads, such as the artist-designer Lewis F. Day in 1906, raised a cautionary finger: 'Artists must be regarded as a hopeful race, periodic fits of despondency notwithstanding. And they show it in their readiness to believe in the artistic possibilities of the poster. There

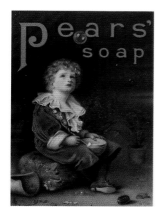

is one great obstacle in the way of its artistic development, viz., the aim and purpose of advertisement.'

Nothing characterised the commercial imperative of the poster more perfectly than the fate of Sir John Everett Millais's picture *A Child's World*, popularly known as 'Bubbles'. The painting was exhibited by Millais at the Academy in 1886 and sold, crucially with copyright, to the proprietor of the *Illustrated London News*. Colour reproductions of the painting had a wide circulation and attained immediate popularity. The painting and its copyright then found their way to the manufacturers of Pears Soap who used it as the basis for one of the nineteenth century's most successful promotional campaigns. Millais was initially furious, until he acknowledged there was nothing he could do to prevent it.

The reaction of the cultural press was scathing, claiming that Millais had brought about the degradation of art. He was deeply wounded and the lesson was not lost among the other Academicians, many of whom became rigid in their opinion that the poster was now beneath their dignity. Artists did continue to design posters in Britain – often as a sideline to pay the bills – and some exponents even progressed to membership of the Royal Academy. But the Academy itself did not regard posters as a valid form of art. For many years it refused to promote its exhibitions through posters and was content to support the notion that unregulated advertisements amounted to the despoliation of London's streets.

When the Academy deigned to employ posters as a means of publicising its exhibitions, it did so with extreme reluctance and for very pragmatic reasons. Starting in 1910, public attendance at the Summer Exhibition began to decline dramatically. The financial consequences of this were hard to ignore as the Academy relied wholly, then as now, on private income. A Ways and Means committee was established and it recommended that the Academy should commission a poster, but this proposal was refused by the Academy's General Assembly. Even so, there is evidence that a compromise was reached: a poster from this date does exist and is preserved in the London Transport Museum. It was part of the Underground network's 'Humours of London' series, designed by Tony Sarg, which promoted various attractions in the capital (page 8). As the poster was part of London Transport's publicity machine the Academy could shrug and claim it retained an unblemished record of institutional aloofness.

The outbreak of the Great War was calamitous for the fortunes of the Academy. Thirty-five students and former students made the ultimate sacrifice during the fighting

Chromolithograph advertisement published by A. & F. Pears Ltd featuring *A Child's World* by Sir John Everett Millais RA, c. 1889.

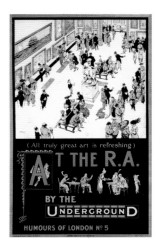

and in 1917 the building was directly bombed, severely undermining the Academy's financial foundations. Summer Exhibition attendance had now fallen to around 160,000, from a peak in 1879 of 391,000, and there was a real fear that the Academy could no longer sustain itself without significant change. With reluctance the Council acknowledged that publicity might be required to boost attendance, as minutes from a 1918 meeting explain: 'It was resolved that advertisements of the Summer Exhibition be placed in certain stations of the Underground Railways at a cost not exceeding £50.'

Paper was still rationed and the resulting poster was so basic as to resemble something from the 1850s. Copies were placed at carefully selected stations on the London Metropolitan Railways, without great effect. Unsurprisingly it was agreed that a more substantial effort should be made and advice was sought from Viscount Burnham, owner of the *Daily Telegraph*. One of his suggestions was that the Academy should commission a graphic poster and Sir William Orpen undertook the design. Although there is evidence that it was printed and ordered to be displayed in the summer of 1924, so far no surviving copies have been located.

The interwar period was a golden age for the British poster. Huge corporations such as Shell, London Transport and the General Post Office expressed their corporate identity through the use of innovative visual design. The distaste that many artists had felt for posters began to fade and major names, such as Frank Brangwyn, Paul Nash and Dame Laura Knight, undertook poster commissions.

At the same time the Royal Academy became London's premier venue for ambitious exhibitions, which were rapidly dubbed 'blockbusters'. The scale of these exhibitions went beyond anything previously seen at the Academy. Publicity was integral to their success and it became routine for an attractive poster to be created. In this context it is not surprising that thoughts turned to a new poster for the Summer Exhibition, which had begun to resemble a poor relation. Henry Rushbury, then an Associate Academician, was commissioned to produce a drawing of Burlington House and this image formed the centrepiece of the poster for 1933 (page 17). Two further excursions into graphic design were attempted during the 1930s, with posters from Laura Knight and A. R. 'Tommy' Thomson (pages 18–19), but the underlying anxiety as to whether the Academy should indulge in publicity at all never went away. With the renewed outbreak of hostilities in 1939 the Academy retreated once more to typographic designs (pages 20–25).

Even after the war a residual snobbery against posters clung to the higher reaches of British culture. Philip James,

Telephone:
London Wall 3651 (2 lines).

Telegraphic Address:
"Telotype, Cent, London."

97, GRESHAM STREET,
BANK,

LONDON, E.C. 2 May 19 **18**

The Royal Academy of Arts.,

Burlington House, Piccadilly, W.

Dr. to WALTER JUDD, LTD

PLEASE RETURN THIS ACCOUNT WITH REMITTANCE.

No Receipt valid unless on printed official Receipt Form.

DATE 1918.		PRICE		
To exhibiting posters on the following Metropolitan Stations, 3 each.				
Euston Square Portland Square Baker Street Edgware Road Praed Street Queens Road, Bayswater. Notting Hill Gate High Street, Kensington. Gloucester Road, South Kensington.	for 13 weeks commencing May 6th.1918.	12	15	-
To exhibiting posters on the following Stations. Metropolitan District Railway				
Charing Cross 3 Temple 3 St.James Park 3 Victoria 3 South Kensington 3 Gloucester Road 3 Earls Court, Brompton 3 High Street, Kensington. 3 West Kensington.3 Piccadilly Tube. Earls Court 3 Gloucester Road 3 South Kensington 2 Brompton Road 3 Knightsbridge 3 Hyde Park Corner 3 Down Street, Piccadilly. 2 Dover Street 3 Piccadilly Circus 3 Leicester Square 2 Covent Garden 3 Holborn 2 Bakerloo Tube. Charing Cross 2 Trafalgar Square 3 Piccadilly Circus 3 Oxford Circus 3 Regents Park 3 Baker Street 3	for Fourteen weeks commencing May 11th.1918.	21	-	-
		£ 33	15	-

(handwritten in left margin:) This is included in the Receipted a/c of 86-8-2

Director of the Arts Council, wrote to Sir Gerald Kelly, the Academy's President in 1952 and sniffed, 'The posters that you and we produce are much above the average level and bring a certain amount of dignity to the hoardings.'

In retrospect this opinion is debatable, as the Academy relied on its longstanding stationers, William Clowes Ltd, to produce posters that displayed a minimal concern for aesthetics or innovation. All this changed when the artist and designer Theo Ramos was asked by his father-in-law, then Keeper of the Royal Academy, Henry Rushbury, to take charge of designing the Academy's posters. In a recent conversation Tod Ramos, Theo's son and Henry Rushbury's grandson, recalled how his father worked:

> Throughout Rushbury's tenure as Keeper, my father did the posters. They were all hand-done, the early ones. My father was trying out this water-transfer technique. He couldn't make it work. He was having a nightmare of a time and my grandfather came into the studio and because he was exhausted, exasperated, said: 'Come on, we'll go up to Dover Street Arts Club and have dinner.' My father ordered soup of the day and, you know what? It was alphabet soup. It was like an H. M. Bateman cartoon, a graphic artist's nightmare.

Theo Ramos designed all his posters in the studio at the top of the Keeper's House. In this homespun manner he introduced to Academy publicity some modern concepts of graphic design. With the development of Letraset transfers in the early 1960s Ramos adopted contemporary sans-serif type, and repurposed his father-in-law's 1930s drawing of Burlington House to dramatic effect (page 27). Crucially, he was advised by two pioneers of British silk-screen printing, Chris Prater and Gordon House of the Kelpra Press. Joe Tilson recalls the importance of Prater and House to post-war British printmaking:

> [Gordon] was a key figure in starting printmaking in London because he was a great friend of Chris Prater. Chris printed the posters that Gordon did for the Arts Council in this little flat in Kentish Town and Gordon got in touch with [Eduardo] Paolozzi and said, 'You could make art with this technique called screen printing.' The first person to work there was Paolozzi, and then Gordon and then I did a print, then Richard Hamilton and R. B. Kitaj. And then Richard thought, 'Why doesn't everybody do a print?' So he went to the Institute of Contemporary Arts and set up an ICA print project, which meant then you got [William] Turnbull, David Hockney and so on; all the London artists did prints for a folio called the ICA Print

Project. Gordon was very much interested in commercial art, and therefore artists like myself, who were interested in using commercial art processes, worked through him and with Chris Prater doing these things.

In the 1960s Gordon House at the Kelpra Press became the Academy's main partner for the design and production of posters. It was a relationship that endured for thirty years.

The Academy's finances remained in a perilous state in the mid-1960s and it was generally accepted that publicity for the Summer Exhibition was an absolute necessity. Leonard Rosoman was a member of the Academy's 1965 hanging committee and so felt the need for an effective promotional campaign more keenly than most. He became a vocal champion for publicity and in a subtle shift the poster for 1965 replaced the previous year's photomontage of visitors walking towards Burlington House with a sepia-toned detail taken from his own painting, *A Meeting in the Country* (page 30), a large work hanging in Gallery III. For the first time a work from the show had found its way onto the poster. This was a definitive shift in Academy policy.

In January 1966 the Council decided that each Summer Exhibition should have a poster designed by a Royal Academician, and that year Edward Bawden tentatively agreed to undertake the task. So began an annual game of deadlines, whereby an artwork was commissioned in January, to be painted, designed as a poster, adjudged and printed in time for the start of a promotional campaign in May. Bawden almost immediately wrote to decline the job, 'I explained to Sir Charles [Wheeler] that I had heavy commitments & did not wish to make a promise to undertake the design.' John Bratby stepped in and, with Gordon House supplying the graphic design, created a dramatic and colourful poster that marked a complete break with tradition (page 31).

Bratby's design stands at the head of a grand sequence of posters from some of Britain's most famous artists. In the wider world of promotional design the specialist commercial artist had already been pushed to the periphery but the Academy, in typical fashion, swam against the tide. It showcased the creative possibilities of artistic collaboration, with all the risks this entailed. When, in 1973, the young Associate Academician Anthony Green submitted his design the Council unanimously applauded it (page 38). What happened next was quite unexpected, as Anthony Green himself explains:

Ken Tanner phoned me up and said, 'We've got a problem. London Underground are refusing to accept

the poster because of their fear of graffiti.' Basically they didn't want sex on the tube. I said to Ken, 'Look, tell them that in 24 hours I can produce an overprint of a ball gown on the young lady, so that nobody can be offended.' So I rushed home with a bit of tracing paper, from the proofs drew a quickie overcolour sketch in French ultramarine, and that was it. So, as it happened, you came into London on the Overground and the nude poster was on the station platforms; you dived down below stairs and suddenly she's got a dress on.

Some members were able to make deeply personal statements through the poster commission. Sonia Lawson was chosen to produce 1993's poster (page 61), and the task could not have come at a more difficult moment:

At the time that I was invited to do a poster, my mother suffered a massive stroke. She had to leave her home in Wensleydale and come to live with us – my husband, daughter and me – in Bedfordshire, where I cared for her. It was a time of feeling trapped, but I thought of the rabbit that came into her garden each morning in the Dales: blithe, fit, free, leaping with joy, a simple demo of freedom.

Philip Sutton's 1980 poster (page 45) led to major changes in both his personal and professional life:

Sam Wanamaker, you probably know who he is, well he bought the poster and he was so amazed to find that he thought it looked like his daughter Zoë that he got in touch with me. He asked me would I help him to raise funds for the Globe Theatre project, because they needed the money to build it. We became friends and I met Zoë and out of that he suggested that maybe I would like to do an exhibition based on Shakespeare. So from that moment on I did a whole number of rather large canvases, which I actually exhibited at the Royal Academy, and they went up to Leeds, they went to Stratford-upon-Avon. I can't remember exactly, but it was three-and-a-half- to four-and-a-half-years' work. Off one poster!

In 1988 Norman Adams produced a spectacular design that the Council received with wild acclaim (page 55). It was a gouache painting, the same size as a standard double crown poster, with all the usual typography fully integrated into the composition. As a painting it was a triumph, but as a promotional advert it failed. At the following Council, discussion ensued: 'It was suggested that the Summer Exhibition poster design should be entrusted

to a professional graphic designer, who might choose from a "pool" of Members in order to develop the selected Member's work into a poster design. The alternative was for the artist to attempt to design a poster (not a work of art in itself).'

The question of the difference between a poster and a work of art became an ever more pressing issue and was debated very seriously. In this sense it was a conversation that had its origin in the very roots of the medium. Paul Huxley was one of the last Academicians to work with Gordon House on a poster for the exhibition. He created a work specifically for the commission, altering his normal working practice to suit:

> When I was asked to do it I phoned up Joe Tilson, because I liked his poster, and he said, 'Call Gordon House.' My normal habit would be to make a square format, but I made it on a longer sheet of paper leaving a space to allow for the lettering, and I think that's the way the original sheet was, a creamy paper. It was easy working with Gordon. I mean I knew his work very well, he was a painter too.

Huxley's design (page 58) suggests aspects of both painting and sculpture, and in doing so sought to reflect the variety offered by the exhibition; but this sensitivity to the work of others was something of an exception. By the end of the 1990s arguments against using an Academician's design were beginning to mount. It was recognised that no single image could reflect the exhibition's intrinsically democratic nature. Posters began to proliferate as attempts were made to represent sculpture and architecture.

The Academy could not remain immune to the increasingly complex world of contemporary marketing techniques, and the growing sophistication of public relations did not allow for the annual risk-taking epitomised by an artist-designed poster. Since the mid-2000s the Academy has frequently relied upon the skills of a professional design house to lead on poster design, and the power of modern brand identity has located the Summer Exhibition securely within the Academy's wider exhibition programme. These changes have perhaps curtailed the free expression that made earlier posters so exciting, if idiosyncratic. But one thing has not changed. A good poster, a powerful image, remains an effective driver of attendance and visually anchors the Academy's Summer Exhibition in the imagination of the British public. Long may it continue to do so.

Mark Pomeroy would like to thank RA Publications, as well as Anthony Green, Paul Huxley, Sonia Lawson, Leonard McComb, Tod Ramos, Joe Tilson and Anthony Whishaw, who were all helpful and generous in sharing their recollections.

The Posters

ROYAL ACADEMY

SUMMER EXHIBITION

NOW OPEN

9 a.m. to 7 p.m.

Admission 1s. 6d.

Catalogue 1s.

Season Ticket 5s.

WILLIAM CLOWES & SONS, Ltd., Printers to the Royal Academy

ROYAL ACADEMY

■

SUMMER EXHIBITION

9 A.M. TO 7 P.M.

■

ADMISSION - - -	1s. 6d.	
CATALOGUE - -	1s. 0d.	
SEASON TICKET -	5s. 0d.	

W. H. SMITH & SON, THE ARDEN PRESS, STAMFORD STREET, LONDON, S.E.1 F 25409

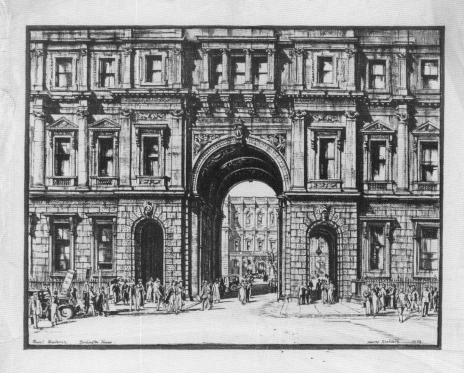

ROYAL ACADEMY SUMMER EXHIBITION

9 A.M. TO 5 P.M. 1/6
5 P.M. TO 7 P.M. 1/-

WEEK DAYS · MAY · 2 ~ AUG · 6

WM. CLOWES & SONS, LTD., PRINTERS TO THE ROYAL ACADEMY.

Henry Rushbury · 1933

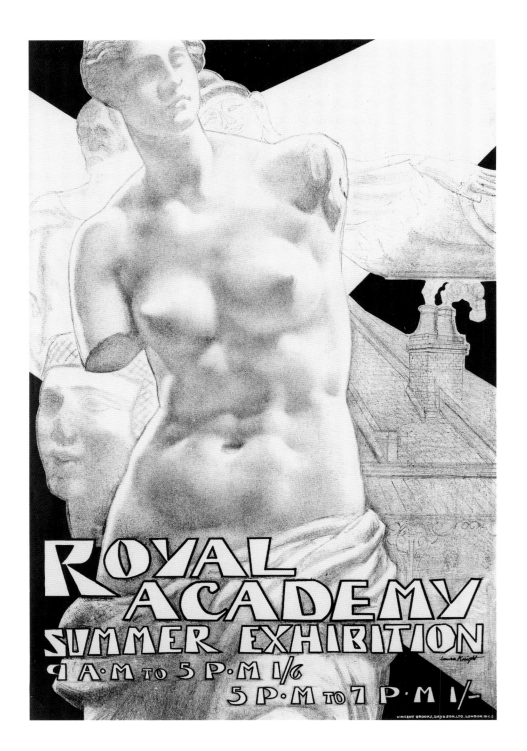

Laura Knight · 1937

ROYAL ACADEMY
OF ARTS

PAINTING
SCULPTURE
ARCHITECTURE

EXHIBITION

MAY – AUGUST

Weekdays: 9.30 - 7 Sundays: 2 - 6

Admission 1/-

CURWEN PRESS

ROYAL ACADEMY
SUMMER EXHIBITION
NOW OPEN
WEEKDAYS 9·30-7 SUNDAYS 2-6

ADMISSION 2/-

WILLIAM CLOWES & SONS, LTD, LITTLE NEW STREET, E.C.4.

1951

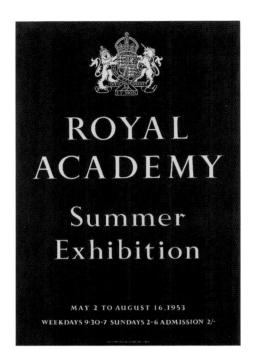

ROYAL ACADEMY
Summer Exhibition
MAY 2 TO AUGUST 16.1953
WEEKDAYS 9·30·7 SUNDAYS 2-6 ADMISSION 2/-

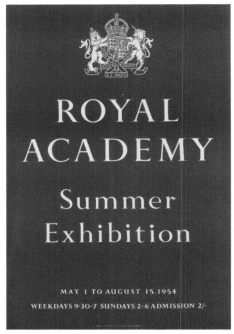

ROYAL ACADEMY
Summer Exhibition
MAY 1 TO AUGUST 15.1954
WEEKDAYS 9·30·7 SUNDAYS 2-6 ADMISSION 2/-

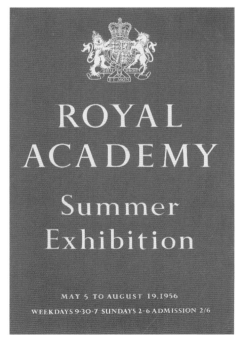

ROYAL ACADEMY
Summer Exhibition
MAY 5 TO AUGUST 19.1956
WEEKDAYS 9·30·7 SUNDAYS 2-6 ADMISSION 2/6

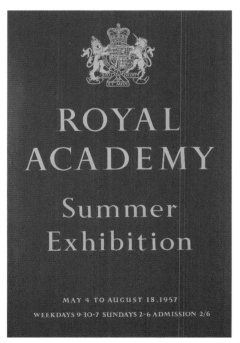

ROYAL ACADEMY
Summer Exhibition
MAY 4 TO AUGUST 18.1957
WEEKDAYS 9·30·7 SUNDAYS 2-6 ADMISSION 2/6

ROYAL
ACADEMY
SUMMER
EXHIBITION
(IN THE MAIN GALLERIES)

IN THE DIPLOMA GALLERY

PAINTINGS BY
SIR WINSTON
CHURCHILL
HON. R.A.

NOW OPEN WEEKDAYS 9.30-7 SUNDAYS 2-6

ROYAL
ACADEMY
Summer
Exhibition
1960

APRIL 30 TO AUGUST 14,1960

WEEKDAYS 9.30-7 SUNDAYS 2-6

ADMISSION 3/- (1/6 AFTER 5 P.M)

ROYAL
ACADEMY
Summer
Exhibition
1960

APRIL 30 TO AUGUST 14 ,1960

WEEKDAYS 9.30-7 SUNDAYS 2-6

ADMISSION 3/- (1/6 AFTER 5 P.M)

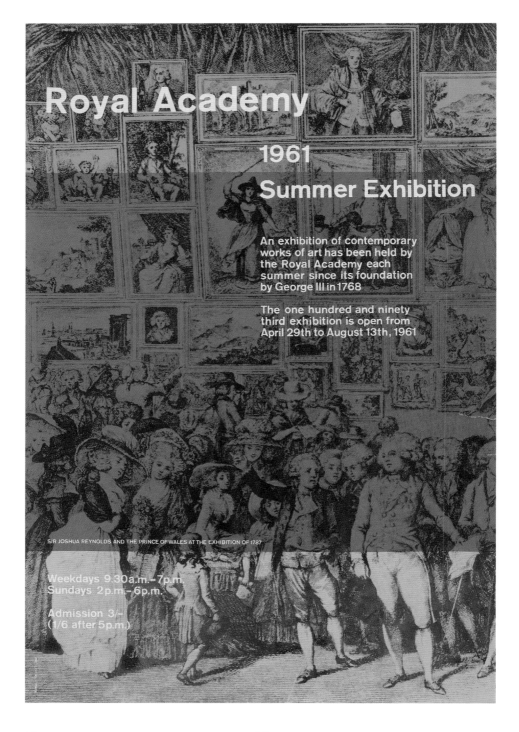

Royal Academy

1961

Summer Exhibition

An exhibition of contemporary
works of art has been held by
the Royal Academy each
summer since its foundation
by George III in 1768

The one hundred and ninety
third exhibition is open from
April 29th to August 13th, 1961

SIR JOSHUA REYNOLDS AND THE PRINCE OF WALES AT THE EXHIBITION OF 1787

Weekdays 9.30a.m.–7p.m.
Sundays 2p.m.–6p.m.

Admission 3/–
(1/6 after 5p.m.)

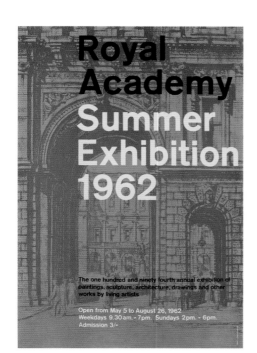

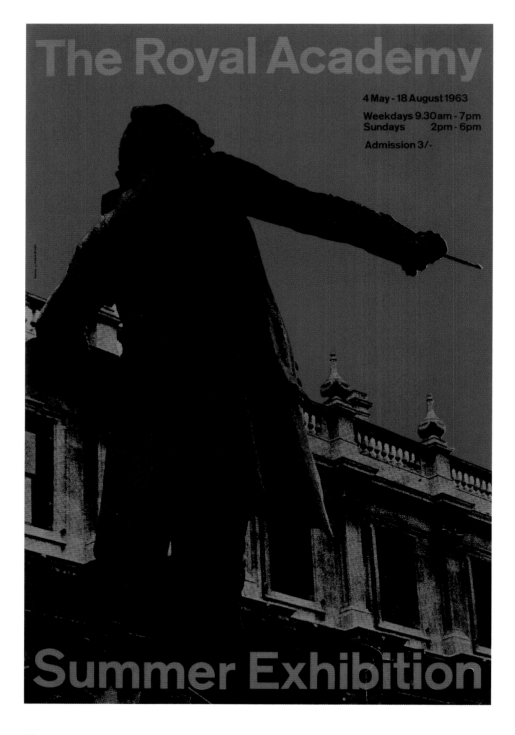

1963

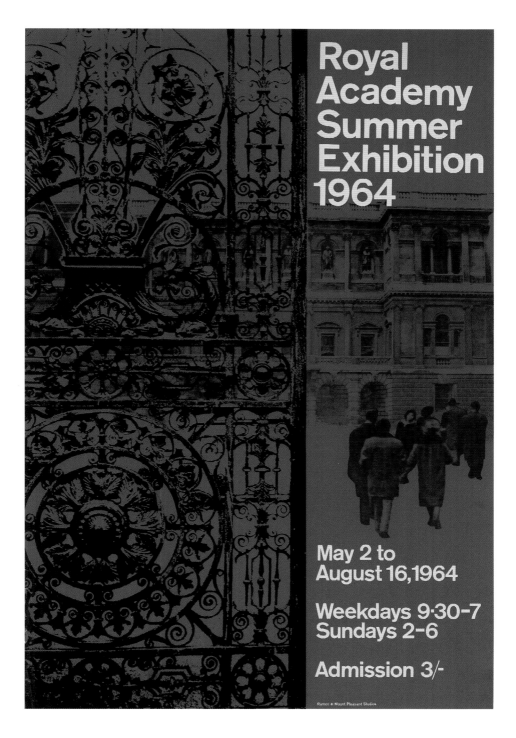

Royal
Academy
Summer
Exhibition
1964

May 2 to
August 16, 1964

Weekdays 9·30–7
Sundays 2–6

Admission 3/-

Ramos + Mount Pleasant Studios

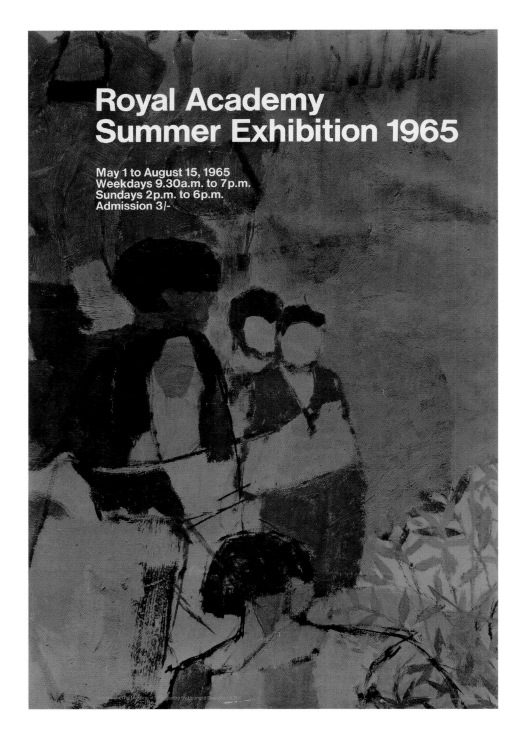

Royal Academy
Summer Exhibition 1965

May 1 to August 15, 1965
Weekdays 9.30a.m. to 7p.m.
Sundays 2p.m. to 6p.m.
Admission 3/-

Leonard Rosoman · 1965

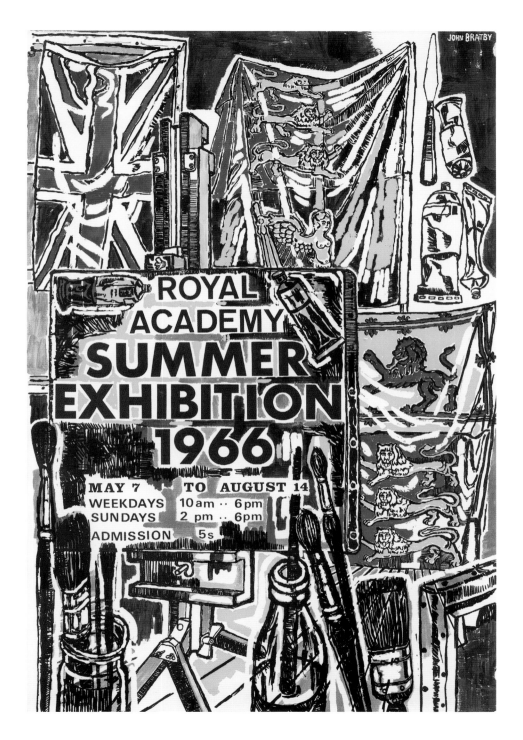

John Bratby · 1966

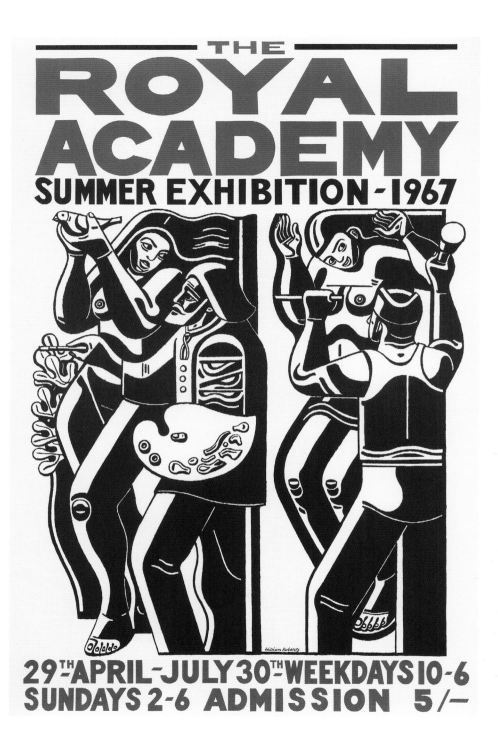

William Roberts · 1967

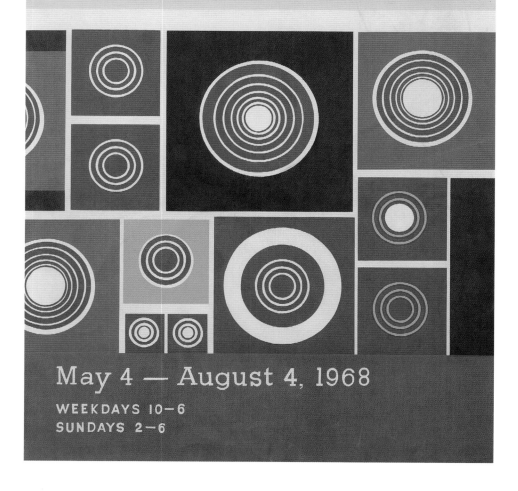

Royal Academy
200th
SUMMER EXHIBITION

May 4 — August 4, 1968
WEEKDAYS 10—6
SUNDAYS 2—6

Edward Bawden · 1968

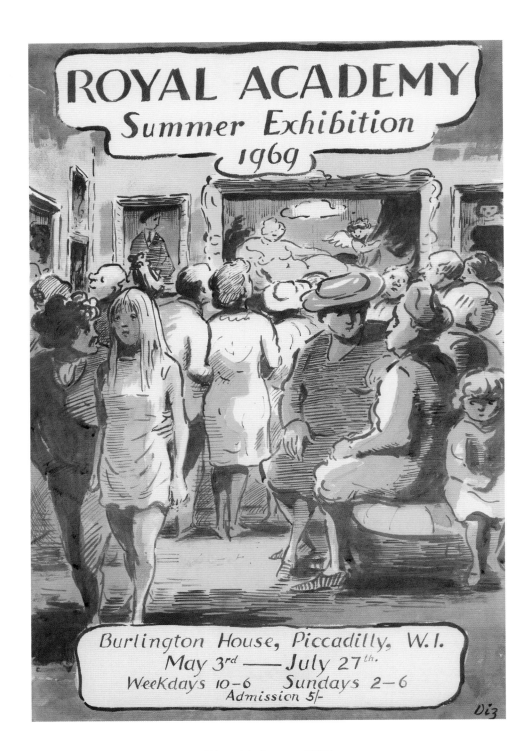

ROYAL ACADEMY
Summer Exhibition
1969

Burlington House, Piccadilly, W.I.
May 3rd —— July 27th.
Weekdays 10–6 Sundays 2–6
Admission 5/-

Edward Ardizzone · 1969

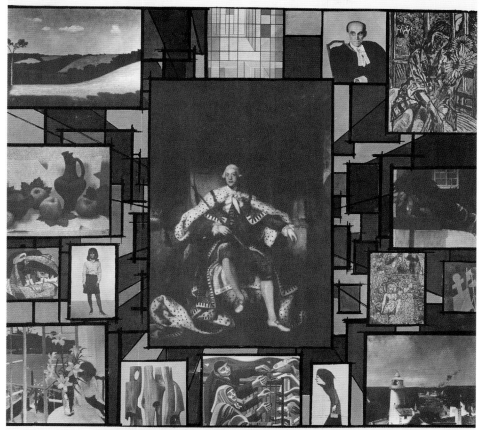

Ruskin Spear · 1970

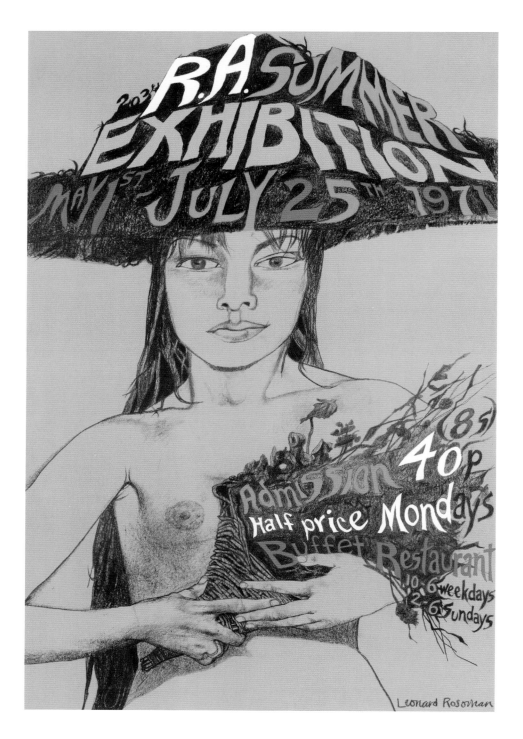

The poster text reads:

203rd R.A. Summer Exhibition May 1st – July 25th 1971

(85) 40p Admission Half price Mondays Buffet Restaurant 10–6 weekdays 2–6 Sundays

Leonard Rosoman

Leonard Rosoman · 1971

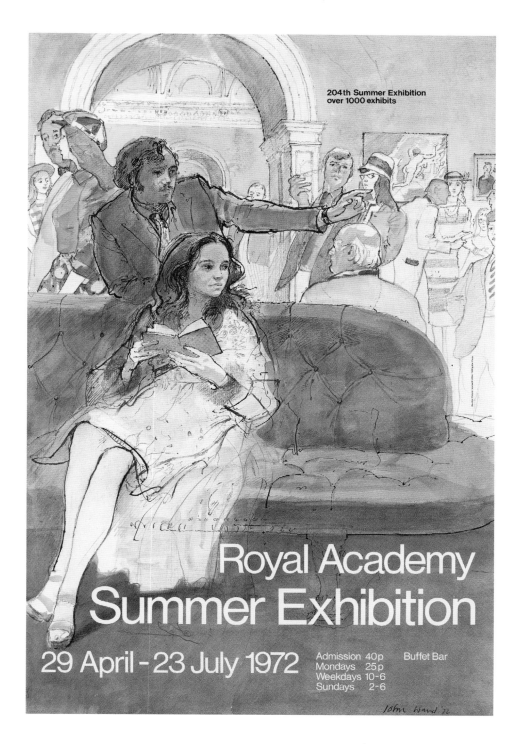

204th Summer Exhibition
over 1000 exhibits

Royal Academy
Summer Exhibition
29 April - 23 July 1972

Admission 40p Buffet Bar
Mondays 25p
Weekdays 10-6
Sundays 2-6

John Ward • 1972

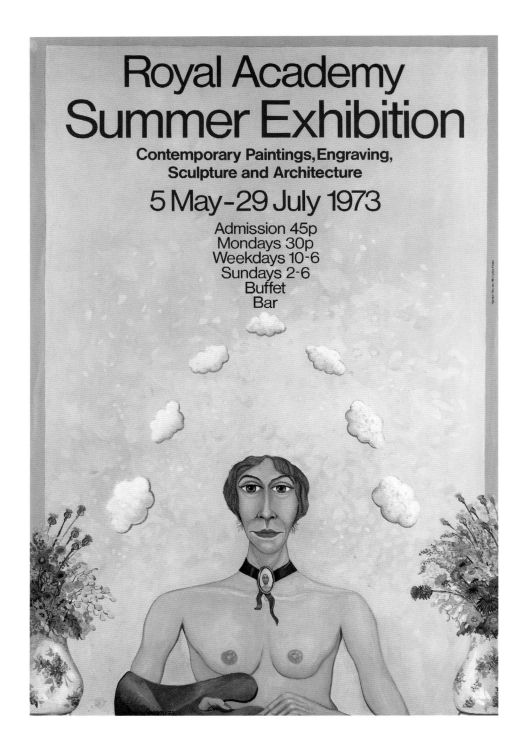

Royal Academy
Summer Exhibition
Contemporary Paintings, Engraving,
Sculpture and Architecture

5 May–29 July 1973

Admission 45p
Mondays 30p
Weekdays 10-6
Sundays 2-6
Buffet
Bar

Anthony Green · 1973

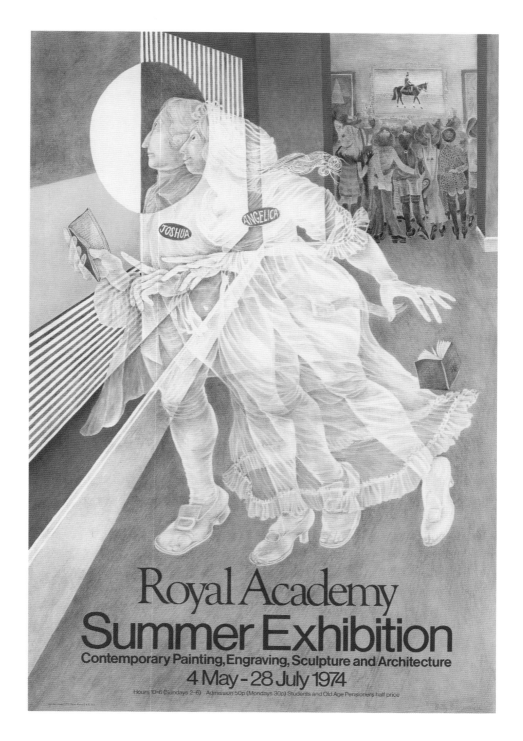

Royal Academy
Summer Exhibition
Contemporary Painting, Engraving, Sculpture and Architecture
4 May - 28 July 1974
Hours 10-6 (Sundays 2-6) Admission 50p (Mondays 30p) Students and Old Age Pensioners half price

Betty Swanwick · 1974

Royal Academy 207th Summer Exhibition of Contemporary Paintings, Engravings, Sculpture and Architecture

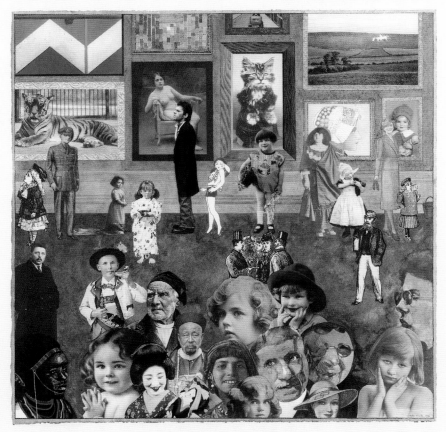

3 May to 27 July 1975
Admission 60p. Mondays 30p.
Weekdays 10 to 6 Sundays 2 to 6

Peter Blake · 1975

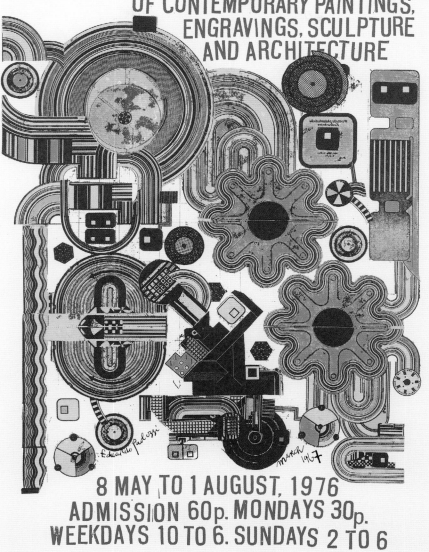

Royal Academy

Summer Exhibition

21 May – 14 August

The Royal Academy, Piccadilly W.I. (opposite Fortnum and Mason)
209th Summer Exhibition. Over 1,000 Exhibits.
Open daily 10 am.–6 pm. Admission 70p. Sundays until 1·45 pm and all day Monday 35p.
Coffee Shop and Bar.

Hugh Casson · 1977

ROYAL
ACADEMY
SUMMER
EXHIBITION

210th Summer Exhibition at The Royal Academy of Arts 20th May–13th August
BURLINGTON HOUSE, PICCADILLY, LONDON W1. OPEN DAILY 10am-6pm. ADMISSION 90p.
SUNDAYS UNTIL 1.45pm-45p. COFFEE SHOP AND BAR.

Donald Hamilton Fraser · 1978

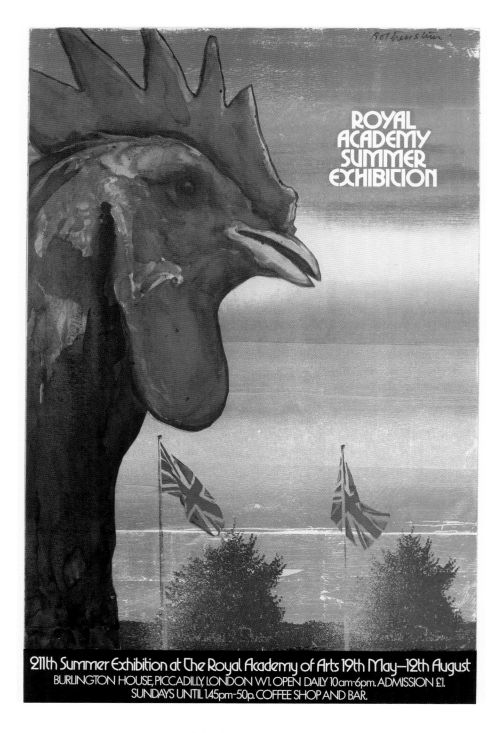

ROYAL
ACADEMY
SUMMER
EXHIBITION

211th Summer Exhibition at The Royal Academy of Arts 19th May–12th August
BURLINGTON HOUSE, PICCADILLY, LONDON W1. OPEN DAILY 10am-6pm. ADMISSION £1.
SUNDAYS UNTIL 1.45pm-50p. COFFEE SHOP AND BAR.

Michael Rothenstein · 1979

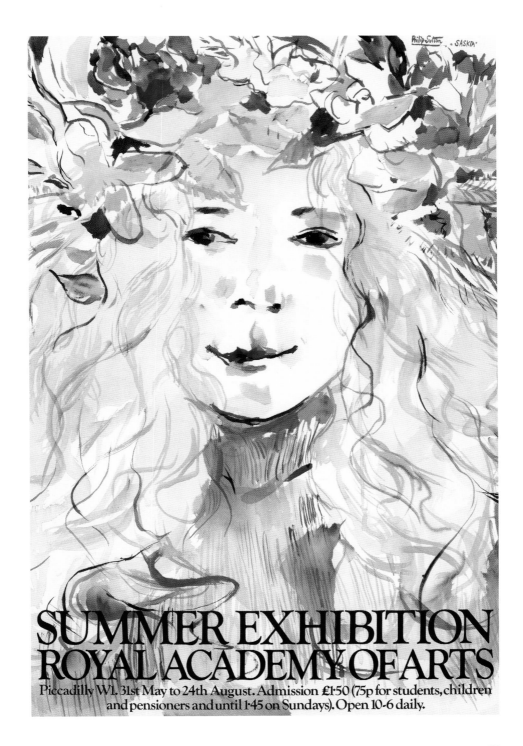

Philip Sutton · 1980

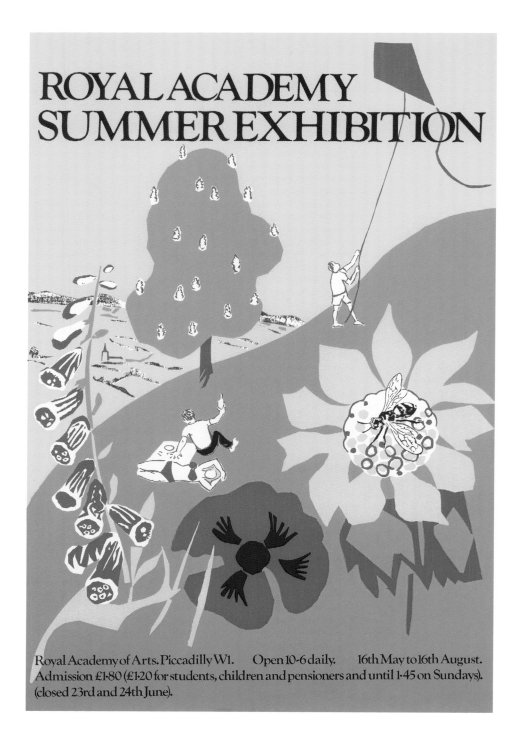

ROYAL ACADEMY
SUMMER EXHIBITION

Royal Academy of Arts. Piccadilly W1. Open 10-6 daily. 16th May to 16th August.
Admission £1·80 (£1·20 for students, children and pensioners and until 1·45 on Sundays).
(closed 23rd and 24th June).

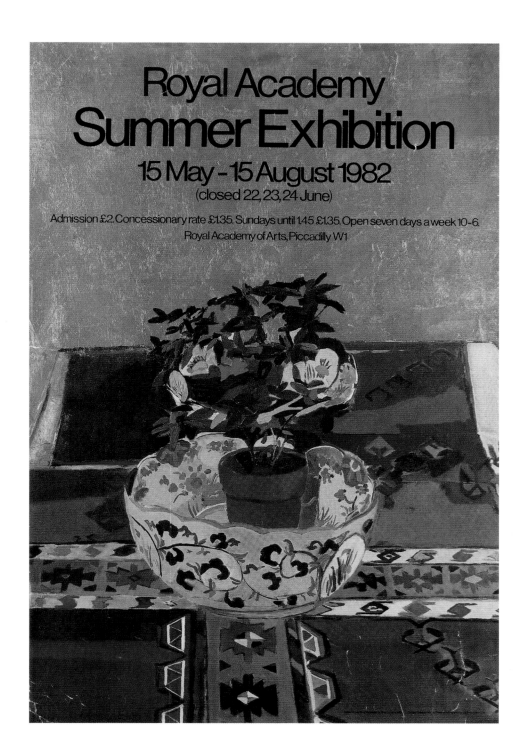

Royal Academy
Summer Exhibition
15 May – 15 August 1982
(closed 22, 23, 24 June)

Admission £2. Concessionary rate £1.35. Sundays until 1.45 £1.35. Open seven days a week 10-6.
Royal Academy of Arts, Piccadilly W1

Ben Levene · 1982

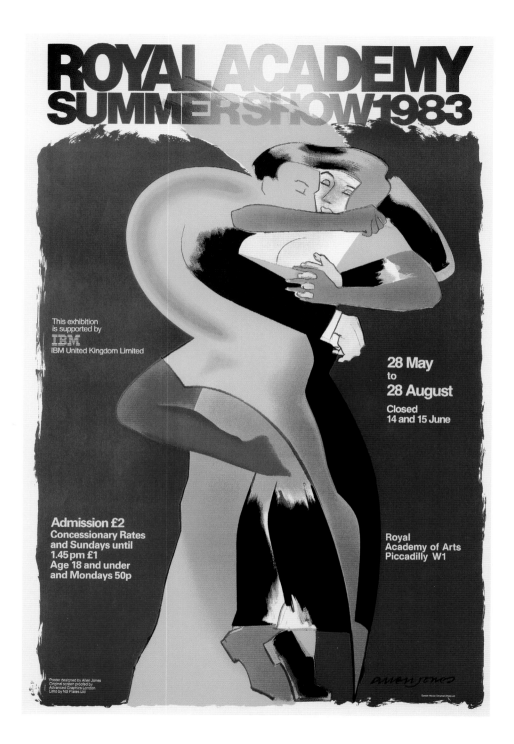

Allen Jones · 1983

SUMMER EXHIBITION
ROYAL ACADEMY OF ARTS

PAINTING BY CRAIGIE AITCHISON ARA

19 MAY – 19 AUGUST 1984, BURLINGTON HOUSE, PICCADILLY LONDON W1.
OPEN 10-6 DAILY (CLOSED 3, 4, 5 JULY) ADMISSION £2.
SUNDAY MORNINGS AND CONCESSIONARY RATE £1.40. 18 YEARS AND UNDER 70p.

SUMMER EXHIBITION
ROYAL ACADEMY OF ARTS

PAINTING BY CRAIGIE AITCHISON ARA

19 MAY – 19 AUGUST 1984, BURLINGTON HOUSE, PICCADILLY LONDON W1.
OPEN 10-6 DAILY (CLOSED 3, 4, 5 JULY) ADMISSION £2.
SUNDAY MORNINGS AND CONCESSIONARY RATE £1.40. 18 YEARS AND UNDER 70p.

Craigie Aitchison · 1984

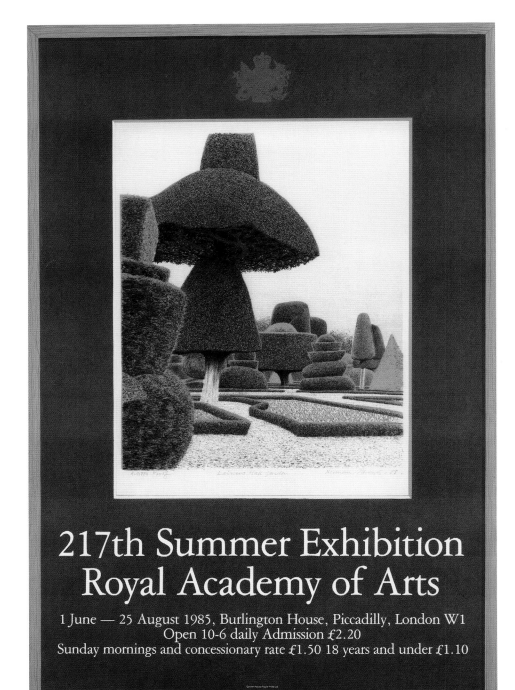

Norman Stevens · 1985

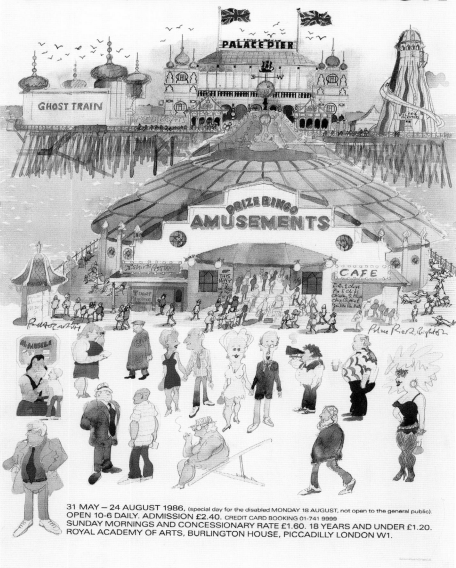

ROYAL ACADEMY OF ARTS
SUMMER EXHIBITION

31 MAY – 24 AUGUST 1986, (special day for the disabled MONDAY 18 AUGUST, not open to the general public).
OPEN 10-6 DAILY. ADMISSION £2.40. CREDIT CARD BOOKING 01-741 9999
SUNDAY MORNINGS AND CONCESSIONARY RATE £1.60. 18 YEARS AND UNDER £1.20.
ROYAL ACADEMY OF ARTS, BURLINGTON HOUSE, PICCADILLY LONDON W1.

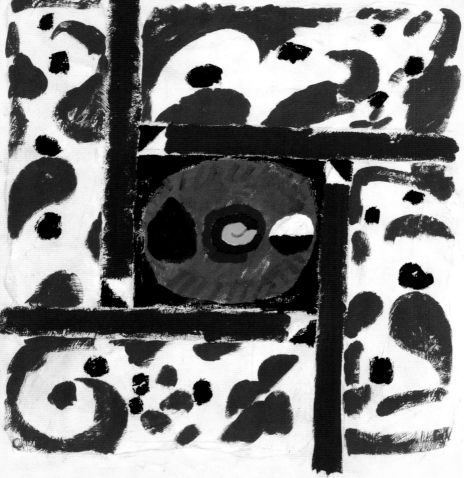

SUMMER EXHIBITION
ROYAL ACADEMY OF ARTS

6 JUNE — 23 AUGUST 1987 (closed to general public 2 & 3 July)
OPEN 10-6 DAILY ADMISSION £2.60
SUNDAY MORNINGS AND CONCESSIONARY RATE £1.75 18 YEARS AND UNDER £1.30

ROYAL ACADEMY OF ARTS BURLINGTON HOUSE PICCADILLY LONDON W1

Tilson 1987

Joe Tilson · 1987

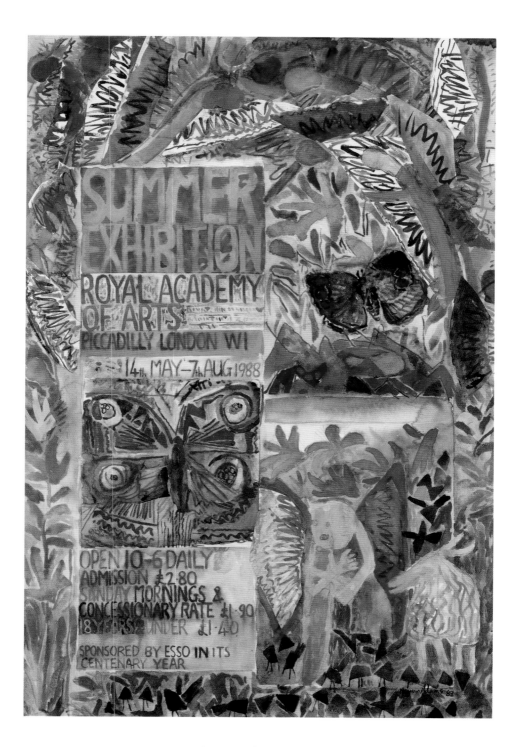

Norman Adams · 1988

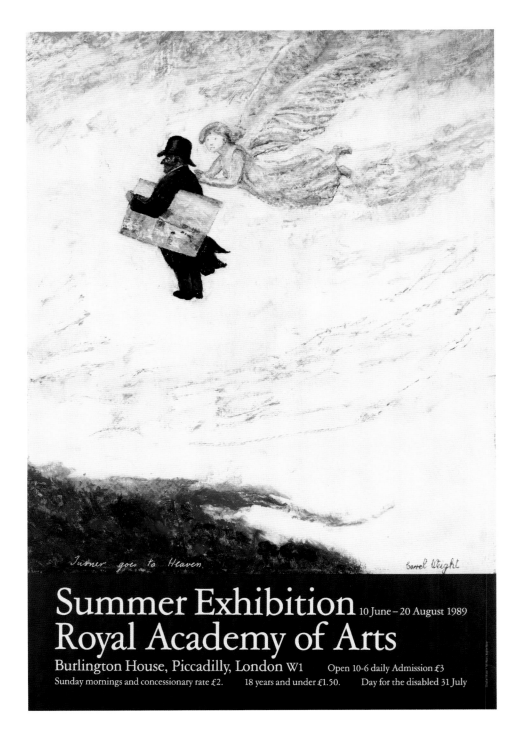

Turner goes to Heaven.

Carel Weight

Summer Exhibition 10 June – 20 August 1989
Royal Academy of Arts

Burlington House, Piccadilly, London W1 Open 10-6 daily Admission £3

Sunday mornings and concessionary rate £2. 18 years and under £1.50. Day for the disabled 31 July

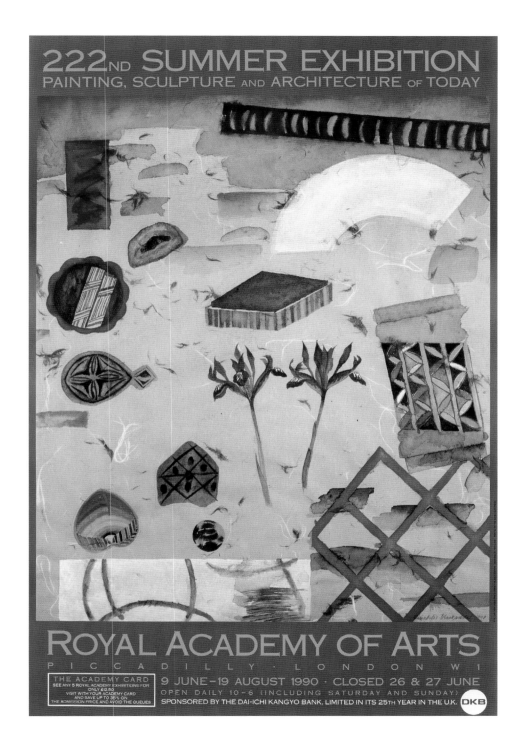

Elizabeth Blackadder · 1990 57

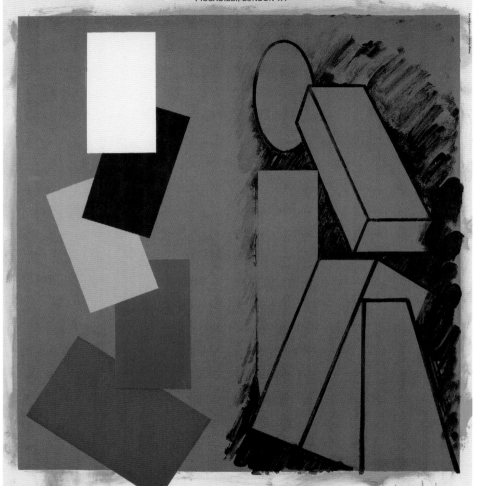

ROYAL ACADEMY OF ARTS

PICCADILLY, LONDON W1

SUMMER EXHIBITION

Painting, Sculpture, Architecture and Prints

In association with GUINNESS PLC

9 June – 18 August 1991
Open Daily 10–6 (including weekends)

Buy your ticket on the day
at the Royal Academy
or book in advance from:
First Call 071-240 7200
Keith Prowse 071-793 1000
Ticketmaster 071-379 4444
Royal Academy 071-287 9579

'Untitled' 1991. Acrylic on paper 76.2 × 58.4cm

ROYAL ACADEMY OF ARTS

PICCADILLY, LONDON W1

SUMMER EXHIBITION

Painting, Sculpture, Architecture and Prints

In association with GUINNESS PLC

9 June –18 August 1991
Open Daily 10–6 (including weekends)

Buy your ticket on the day
at the Royal Academy
or book in advance from:
First Call 071-240 7200
Keith Prowse 071-793 1000
Ticketmaster 071-379 4444
Royal Academy 071-287 9579

SUMMER EXHIBITION

ROYAL ACADEMY OF ARTS

PICCADILLY, LONDON W1. 7 JUNE - 16 AUGUST 1992. OPEN DAILY 10AM-6PM
INCLUDING WEEKENDS. TICKETS AVAILABLE ON THE DAY OR IN ADVANCE FROM:
TICKETMASTER 071-379 4444. FIRST CALL 071-240 7200.

IN ASSOCIATION WITH GUINNESS PLC

Roger de Grey • 1992

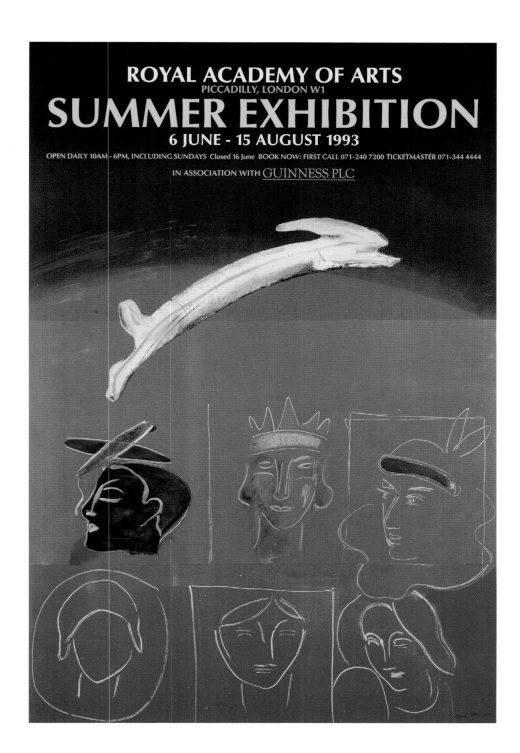

Sonia Lawson · 1993

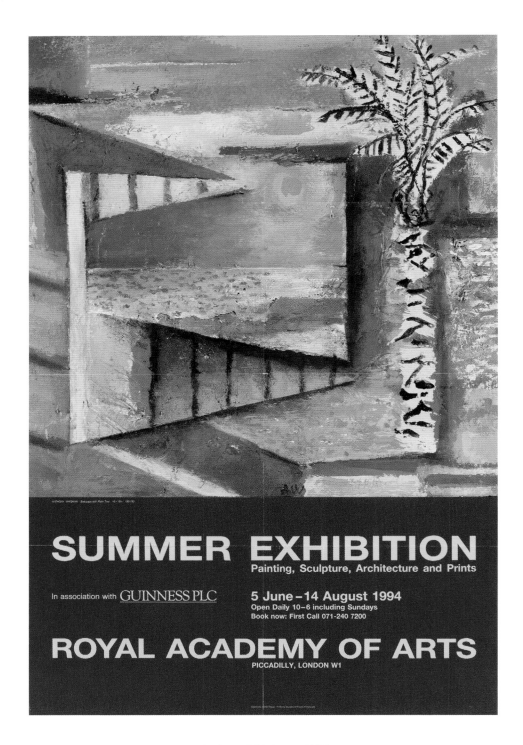

SUMMER EXHIBITION

Painting, Sculpture, Architecture and Prints

In association with GUINNESS PLC

5 June – 14 August 1994

Open Daily 10–6 including Sundays
Book now: First Call 071-240 7200

ROYAL ACADEMY OF ARTS

PICCADILLY, LONDON W1

Anthony Whishaw · 1994

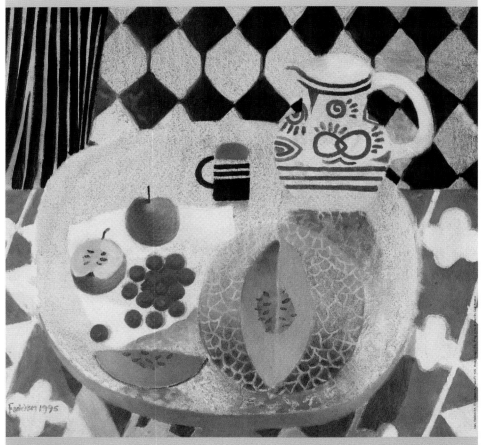

Royal Academy of Arts

Burlington House, Piccadilly, London W1. **4 June – 13 August 1995**

Summer Exhibition
Painting, Sculpture, Architecture and Prints

In association with
GUINNESS PLC

Open daily 10am – 6pm including weekends

Book now: First Call 0171-420 0000

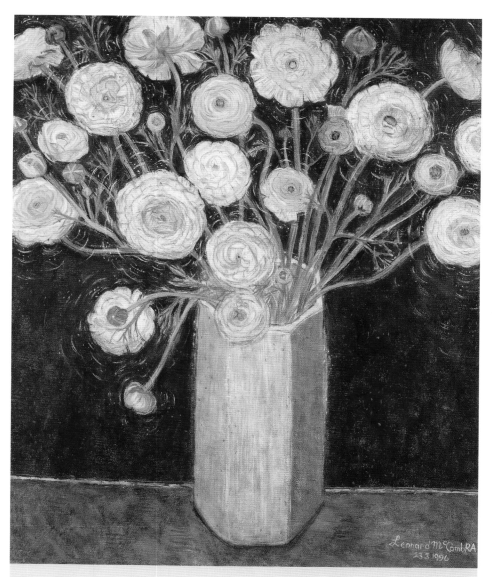

Leonard McComb · 1996

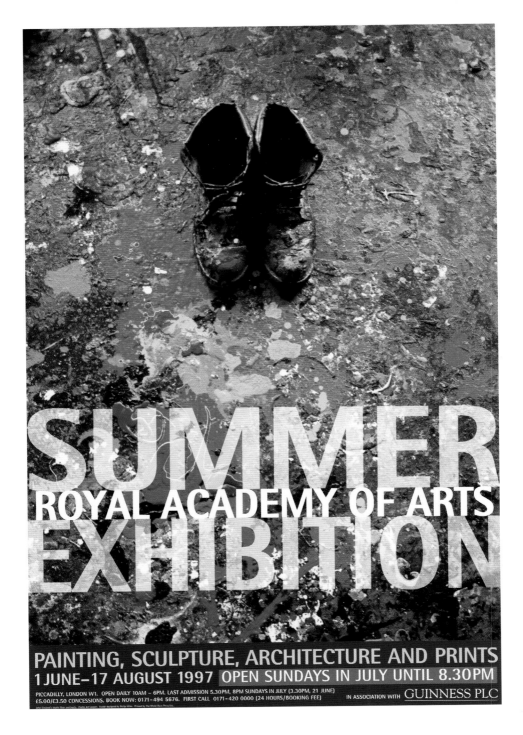

John Hoyland · 1997

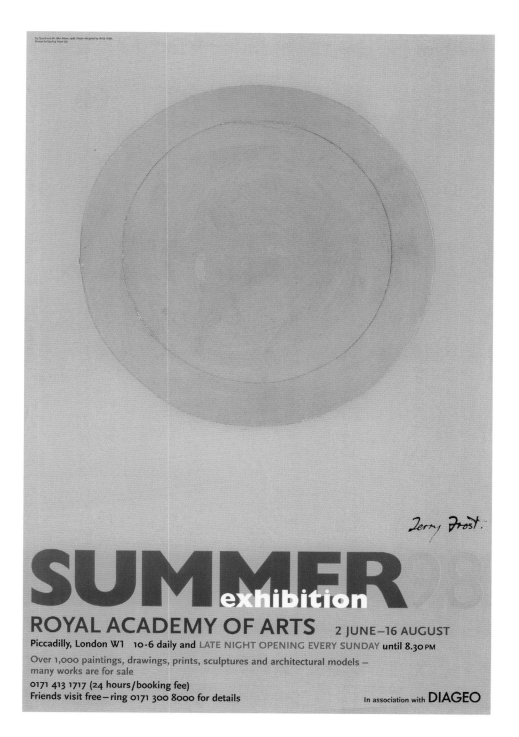

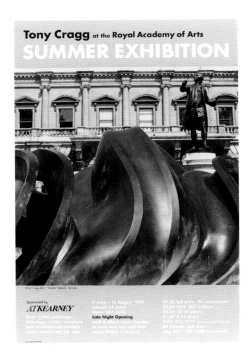

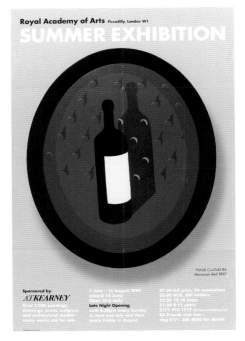

Anthony Cragg · Patrick Caulfield · 1999

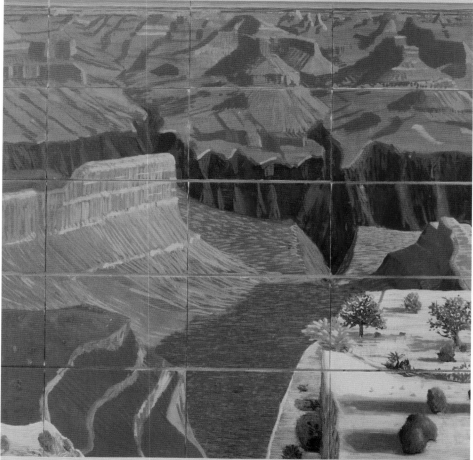

David Hockney at the **Royal Academy of Arts**

SUMMER EXHIBITION

David Hockney "A Bigger Grand Canyon" 1998 (detail), Oil on 60 Canvases, 81½" x 293", © 1999 David Hockney.

Sponsored by

AT KEARNEY

Over 1,000 paintings,
drawings, prints, sculpture
and architectural models –
many works are for sale

7 June – 15 August 1999
(closed 14 June)
Open 10-6 daily
Late Night Opening
until 8.30pm every Sunday
in June and July and then
every Friday in August

£7.50 full price, £6 concessions
£5.00 NUS, ISIC holders
£2.50 12-18 years
£1.50 8-11 years
0171 413 1717 (24 hours/booking fee)
RA Friends visit free –
ring 0171 300 8000 for details

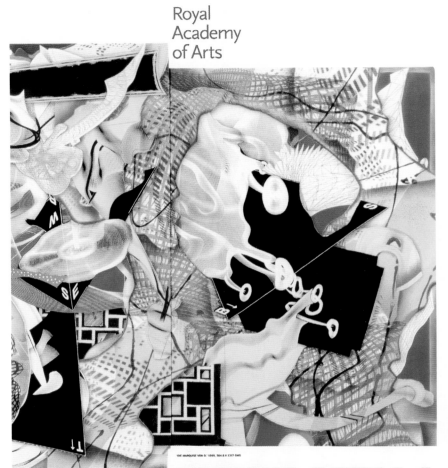

Royal
Academy
of Arts

FRANK STELLA
AT THE **SUMMER EXHIBITION**

29 MAY TO 7 AUGUST 2000
OPEN DAILY 10AM–6PM FRIDAYS UNTIL 8.30PM
www.royalacademy.org.uk

sponsored by *ATKEARNEY*
Management Consultants

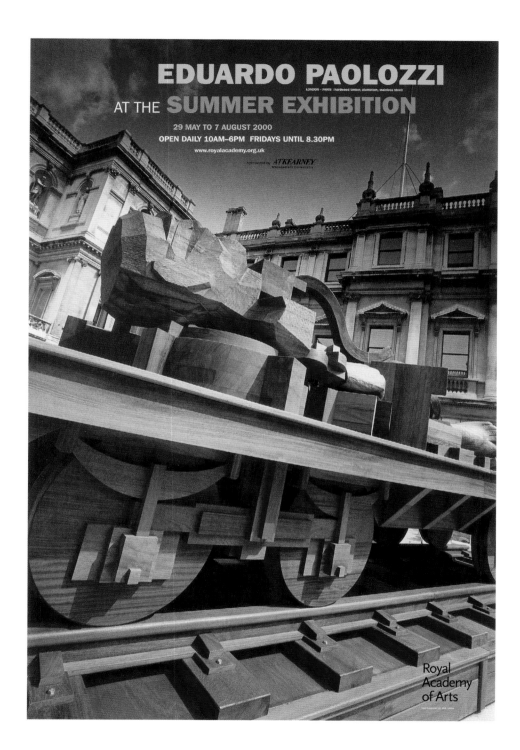

Eduardo Paolozzi · 2000

OVER 1000 PAINTINGS, DRAWINGS, PRINTS, SCULPTURE AND ARCHITECTURAL MODELS – MANY WORKS FOR SALE

Summer Exhibition 2001 No. 233 Sponsored by *ATKEARNEY* Management Consultants

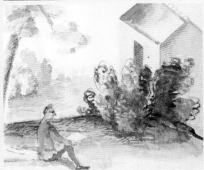

BALTHUS: HONORARY RA

JOHN MORLEY: NON-MEMBER

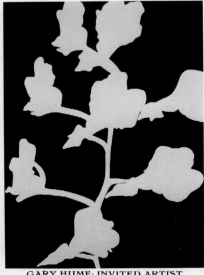

GARY HUME: INVITED ARTIST

CRAIGIE AITCHISON: RA

OPEN
10AM - 6PM

5 June - 13 August
Royal Academy of Arts, Piccadilly W 1
www.royalacademy.org.uk

FRIDAYS
UNTIL
10PM

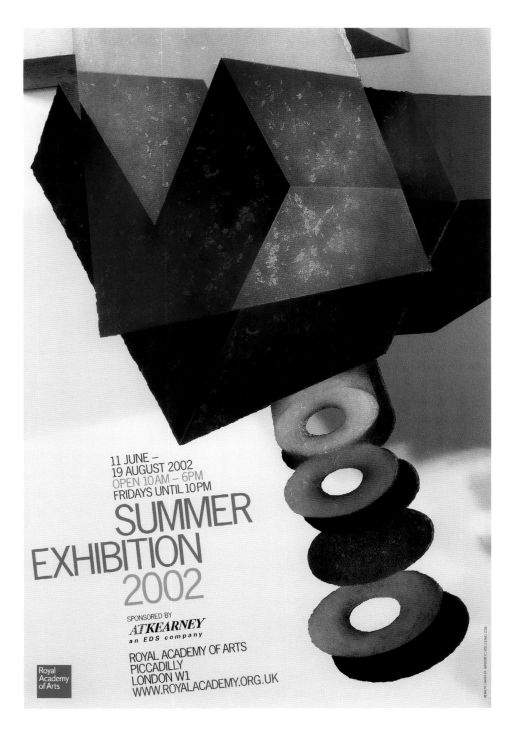

11 JUNE –
19 AUGUST 2002
OPEN 10AM – 6PM
FRIDAYS UNTIL 10PM

SUMMER
EXHIBITION
2002

SPONSORED BY

A.T. KEARNEY
an EDS company

ROYAL ACADEMY OF ARTS
PICCADILLY
LONDON W1
WWW.ROYALACADEMY.ORG.UK

Royal
Academy
of Arts

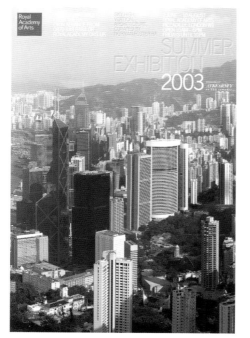

Ben Johnson · Anthony Green · 2003

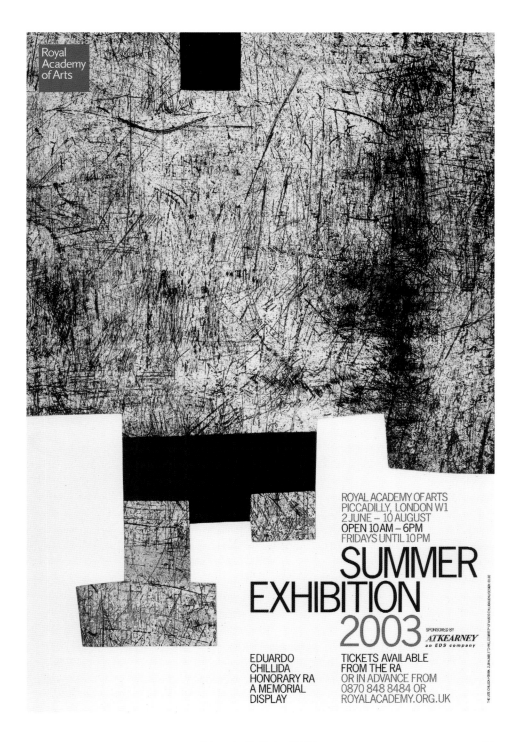

Royal Academy of Arts

SUMMER EXHIBITION 2004

8 June - 16 August
Open daily 10am - 6pm
Fridays until 10pm
Closed from 2pm on 21 June

Tickets on 0870 848 8484
or royalacademy.org.uk

Piccadilly, London W1

SPONSORED BY

David Hockney, *Andalucia. Mosque, Cordova*, 2004 (detail). Watercolour on paper (5 sheets), 74.9 × 110.5cm © David Hockney.

Summer Exhibition 2005
7 June – 15 August
Open Daily 10am – 6pm, Fridays until 10pm
For tickets call 0870 848 8484 or visit www.royalacademy.org.uk
Royal Academy of Arts, Piccadilly W1 ⊖ Green Park or Piccadilly Circus

Ed Ruscha · 2005

77

SUMMER EXHIBITION 2006

12 JUNE TO 20 AUGUST

Royal Academy of Arts

SPONSORED BY

Insight INVESTMENT
HBOS plc

BBC TWO
AS SEEN ON BBC TWO

ROYAL ACADEMY OF ARTS
PICCADILLY, LONDON W1
 GREEN PARK
PICCADILLY CIRCUS

OPEN DAILY 10AM–6PM
FRIDAYS UNTIL 10PM
TICKETS 0870 848 8484
WWW.ROYALACADEMY.ORG.UK

Patrick Caulfield · 2006

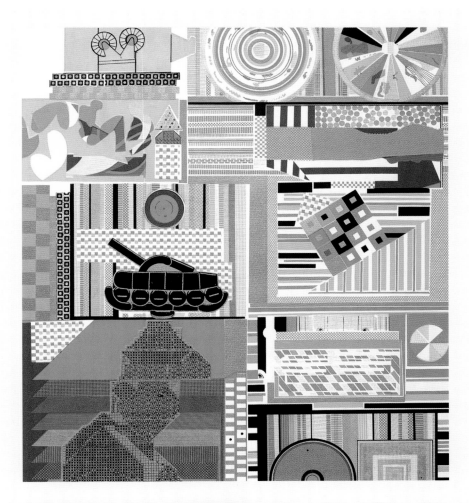

SUMMER 2006
EXHIBITION
12 JUNE TO 20 AUGUST

Royal
Academy
of Arts

SPONSORED BY

Insight
INVESTMENT

HBOS plc

BBC
TWO

AS SEEN ON BBC TWO

ROYAL ACADEMY OF ARTS
PICCADILLY, LONDON W1
GREEN PARK
PICCADILLY CIRCUS

OPEN DAILY 10AM–6PM
FRIDAYS UNTIL 10PM
TICKETS 0870 848 8484
WWW.ROYALACADEMY.ORG.UK

Eduardo Paolozzi · 2006

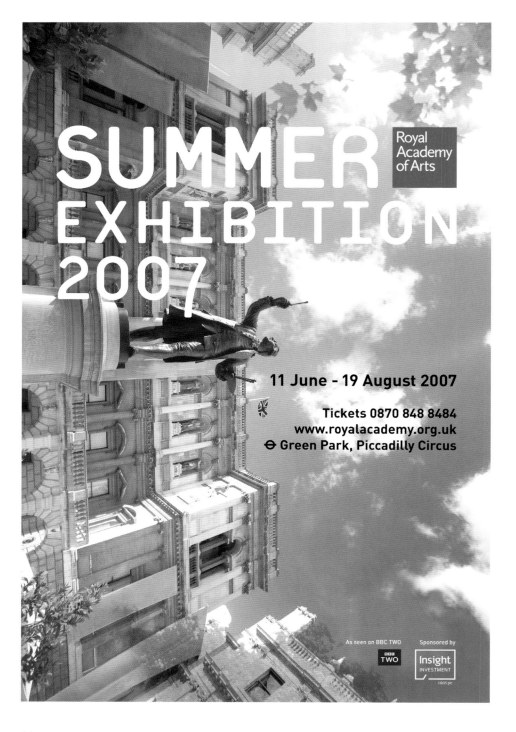

Anthony Caro Jez Braun Lucian Freud Rachel Kneebone Dexter Dalwood Mark Alexander Leonard McComb Peter Freeth The Late R B Kitaj Ron Arad David Mach Ben Levene Will Bailey Ana Maria Pacheco Mick Blake Louise Bourgeois Michael Hopkins Margaret Calvert Renzo Piano Gordon Cheung Clive Barker Coral Churchill Matt Collishaw Jim Dine Jenny Lowe Jane Dixon Nicholas Grimshaw Tara Donovan Mark Dorrian Sophy Dury Tatiana Echeverri Fernandez Helen Frankenthaler Ian McKeever Mary Heilman Michael Fullerton Shaun Gladwell Kip Gresham Sean Griffiths Helene Binet Gabor Gyory Damien Hirst Julia Jacquette Shirazeh Houshiary Elke Krystufek Kengo Kuma Bob Ritson Sigalit Landau Mark Francis Andrew Ratcliffe Flores & Prats Architects Camilla Low Ryan McGinness Julian Opie Mark Dorrian + Adrian Hawker, with Victoria Clare Bernie Quentin Blake Michael O'Mahony Giuseppe Penone Ian Davenport Ben Ravenscroft Jock McFadyen Paula Rego Geoffrey Rigden Vincent Hawkins Dan Rizzie Olwyn Bowey Christoph Ruckhaberle Francesco Clemente Sarah Staton Ed Ruscha Paul Schütze Christopher Shilling Craigie Aitchison James Siena Kiki Smith Francis Soler Celia Paul Laura Stocker Tim Noble and Sue Webster Nigel Hall Chris Wilkinson Sutherland Hussey Architects Antoni Tapies Peter Cook Adrian Berg Ann Christopher Bernard Tschumi Gus Cummins Gavin Turk John Virtue Stephen Chambers Don Walsh Bill Jacklin Gordon Benson Rebecca Warren Elizabeth Blackadder Michael Sandle Gillian Ayres Jennifer Durrant

SUMMER
EXHIBITION
2008

Keith Wilson Peter L. Wilson Lebbeus Woods Raoul Bunschoten Ivar Abrahams Ken Yeang Norman Ackroyd Diana Armfield John Bellany Frank Auerbach Tony Bevan Christopher Page William Bowyer Eileen Cooper Ralph Brown James Butler Jeffery Camp David Chipperfield David Parry Maurice Cockrill Ken Howard Bryan Kneale Tony Cragg Vincent Leow Mary Fedden Frank Bowling Michael Craig-Martin Paul Winstanley Frederick Cuming Trevor Dannatt AOC Architecture Jennifer Dickson William Alsop Tracey Emin Stephen Farthing Edward Cullinan Norman Foster Frederick Gore Juergen Teller Anthony Green Zaha Hadid Donald Hamilton Fraser Albert Irvin Gary Hume Geoffrey Clarke Paul Huxley Flavia Irwin Richard Wilson Eva Jiricna Anish Kapoor Michael Kidner Paul Koralek Sonia Lawson William Bailey Bernard Dunstan Christopher Le Brun Leonard Manasseh Richard Long Alison Wilding John Carter John Wragg Richard MacCormac Basil Beattie John Maine Kenneth Draper James Carpenter Dhruva Mistry David Nash Derek Balmer Allen Jones Humphrey Ocean Joe Tilson Chris Orr Tom Phillips Barbara Rae David Remfry Ian Ritchie Mick Rooney Leonard Rosoman Philip Sutton David Tindle Anthony Eyton William Tucker Gillian Wearing Carey Blake Ian McKenzie Smith Bill Scott Georg Baselitz Richard Rogers Anthony Whishaw Lisa Milroy Anselm Kiefer Mimmo Paladino

9 JUNE – 17 AUGUST
Tickets 0870 848 8484
www.royalacademy.org.uk ⊖ Green Park, Piccadilly Circus

Sponsored by
Insight INVESTMENT

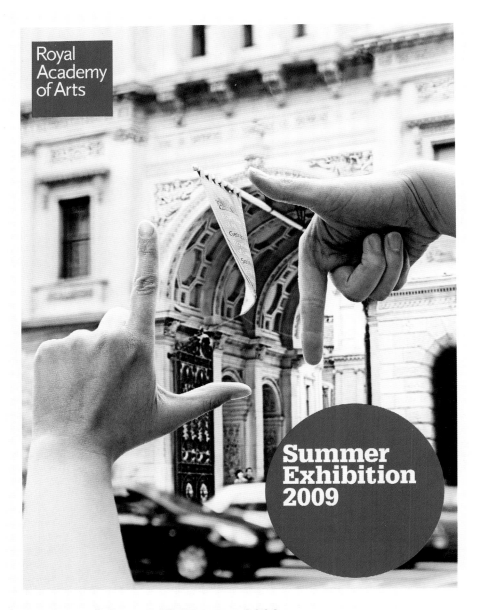

Royal Academy of Arts

Summer Exhibition 2009

8 June – 16 August 2009

Tickets
0844 209 1919 www.royalacademy.org.uk

⊖ **Green Park Piccadilly Circus**

Sponsored by

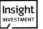

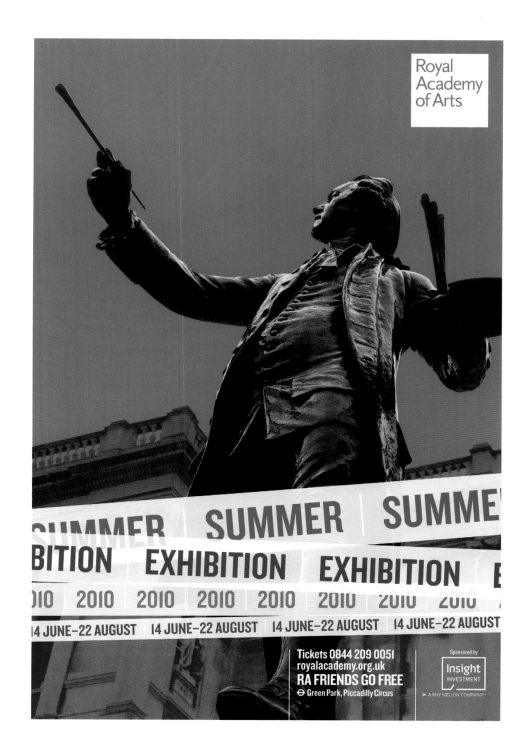

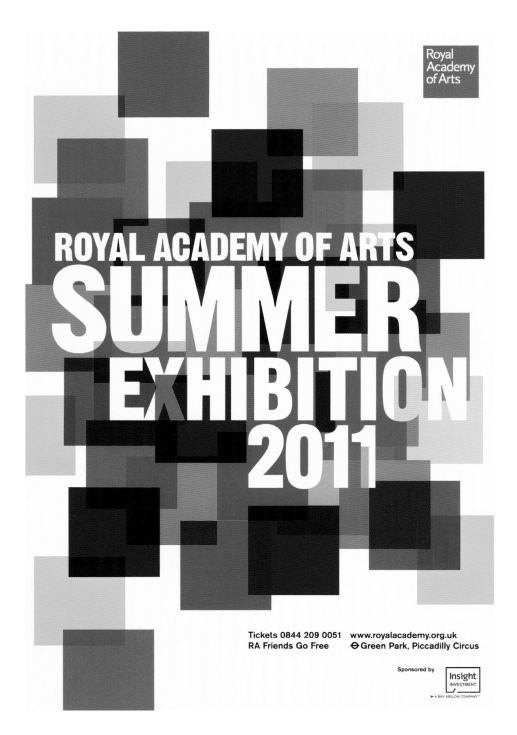

ROYAL ACADEMY OF ARTS
SUMMER
EXHIBITION
2011

Tickets 0844 209 0051 www.royalacademy.org.uk
RA Friends Go Free ⊖ Green Park, Piccadilly Circus

Sponsored by
Insight
INVESTMENT
➤ A BNY MELLON COMPANY™

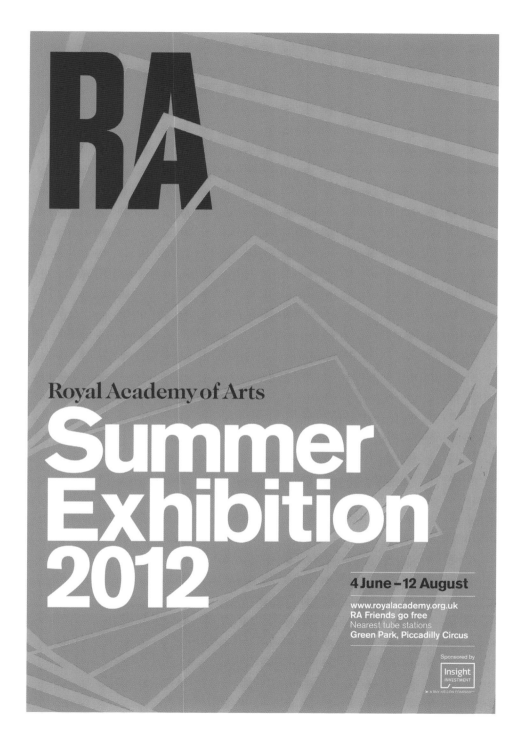

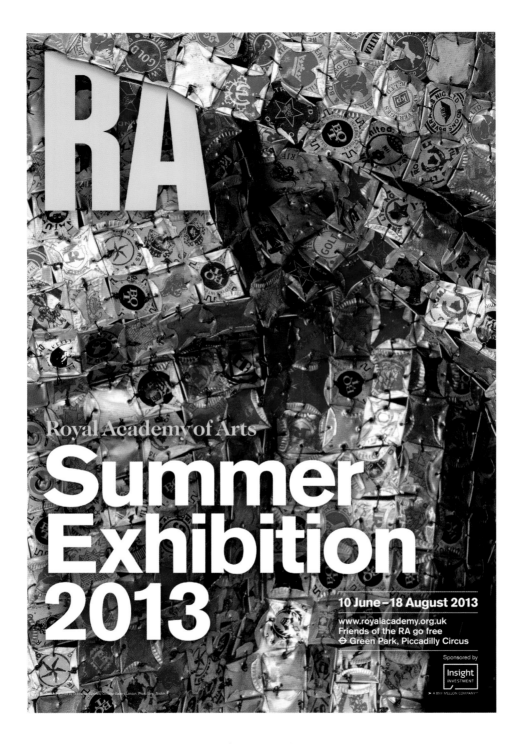

El Anatsui · 2013

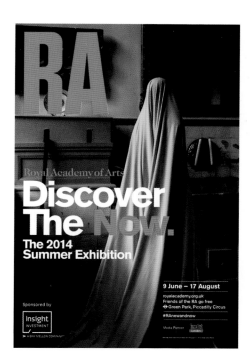
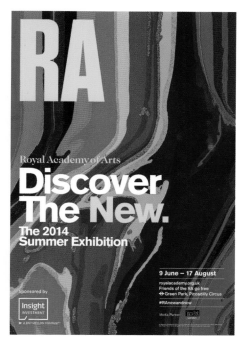

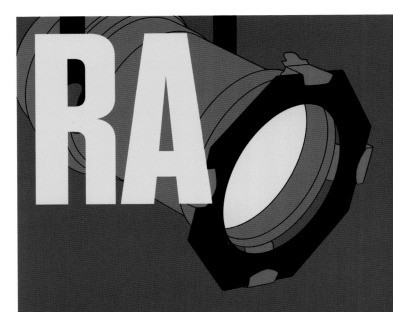

Royal Academy of Arts

Discover
The New.

The 2014
Summer Exhibition

9 June – 17 August

royalacademy.org.uk
Friends of the RA go free
⊖ Green Park, Piccadilly Circus

#RAnewandnow

Sponsored by

➤ A BNY MELLON COMPANY℠

Media Partner

Michael Craig-Martin · 2014

Notes on the Posters

Page 15 · 1918
Designed and printed by William
Clowes & Sons

This basic lithographic poster
appears to be the first produced
officially for the Royal Academy. It
was printed in wartime conditions
while paper rationing was in
effect. Only 113 of these posters
were displayed around the
London Underground. It is almost
miraculous that one survives.

Page 16 · 1922
Designed and printed by
W. H. Smith, The Arden Press

No evidence exists as to why the
Academy commissioned W. H.
Smith's Arden Press to produce
posters in 1922. Evidence from
the same printer securely dates
this poster but otherwise it has
no context and nothing is known
about where it was displayed.
By 1923 the Council was again
debating how to promote the
exhibition effectively.

Page 17 · 1933
Henry Rushbury KVCO CBE RA
(1889–1968), designed and printed
by William Clowes & Sons

In 1929 the Academy hosted the
first in a series of 'blockbuster'
exhibitions of national schools of
art. Vibrant posters formed a part
of each promotional campaign.
Consequently the Council decided
that an image of Burlington
House would be an appropriate
advertisement for the Summer
Exhibition, the suggestion
being that it was the home of
British art. A newly elected
Associate Engraver member,
Henry Rushbury, was chosen. His
image was reused for subsequent
posters in the 1960s.

Page 18 · 1937
Dame Laura Knight RA (1877–1970),
designed and printed by Vincent
Brooks, Day & Son

In 1936 Laura Knight became the
first female Royal Academician
since founder members Angelica
Kauffman and Mary Moser. Knight
was a prolific artist who attained
a high degree of proficiency in
a wide variety of techniques.
London Transport commissioned
her to create several posters in
the 1920s and 1930s, and she
brought her experience to bear
on this design, which was printed
as a lithograph for the Summer
Exhibition of 1937.

Page 19 · 1940
A. R. Thomson RA (1894–1979)

Alfred Thomson grew up unable
to hear or speak. Despite these
disabilities he forged a successful
career that was initially based
around his work as a commercial
artist. This poster would still have
been on display when the London
Blitz began in September 1940,
and soon after Thomson took up
brushes as a war artist for the RAF.
He has the unusual distinction of
winning an Olympic gold medal for
painting at the London 'austerity
games' of 1948.

Page 20 · 1943
Designed and printed by
Curwen Press

The Curwen Press played a
crucial role in British printmaking
at the start of the twentieth
century. Despite suffering
greatly during the war, the Press
continued to operate, producing
government information and
propaganda. This typographic
design would have been a
perfect visual fit with other public-
information posters of the period.

Page 21 · 1951
Designed and printed by William
Clowes & Sons

The printing firm William Clowes
& Sons had been official stationer
to the Royal Academy since 1824.
Their printing techniques and
design had long defined the Royal
Academy's visual identity through
exhibition catalogues, private-
view invitations and other types
of ephemera.

Page 22 · 1953–54
Design by Theo Ramos, printed by
William Clowes & Sons

This is the first Summer Exhibition
poster to be created by the artist
and designer Theo Ramos. The
poster is immediately more striking
than Clowes's earlier in-house
attempt: the design is stripped
to bare essentials, and its visual
purity has continued to influence
graphic designers into the twenty-
first century. In the 1950s the
Academy sought to modernise its
in-house style. After complaints
from the Academicians, a
decision was made to dispense
with Clowes's services for
the production of posters and
illustrated catalogues.

Page 22 · 1956–57
Design by Theo Ramos, printed by
Kelpra Studio

The relationship that developed
between Ramos and Chris Prater
at Kelpra Studio was immediately
successful; Kelpra brought a level
of technical excellence. Screen-
printing widened the palette
available for Ramos's designs
considerably, enabling the use of
vibrant colours more suited to a
Summer Exhibition. The end result
is a colour of deep saturation,
not achievable through standard
offset lithography.

Page 78 · 2006
Patrick Caulfield RA (1936–2005),
design by Spin/Matt Hunt

The year was a sad one in that
the Academy lost two treasured
members; both were the subject
of memorial galleries. Patrick
Caulfield had died in September
2005 and his display, which
included iconic paintings such
as *After Lunch* (1975) and this work
Happy Hour (1996), was curated by
the art historian Marco Livingstone.

Page 79 · 2006
Sir Eduardo Paolozzi CBE RA (1924–
2005), design by Spin/Matt Hunt

The memorial gallery for Paolozzi
was dedicated to work produced
between 1950 and 1970, selected
to display his immense versatility
in sculpture, collage and
printmaking – the image on the
poster, *As is When: Reality* (1965),
was a screen print. The display
was curated by Dr Daniel Herrmann,
Paolozzi Curator at the Scottish
National Gallery of Modern Art,
Edinburgh, the home of Paolozzi's
preserved studio.

Page 80 · 2007
Design by Why Not Associates

In the mid-2000s the decision
was made to once again
move away from using artists'
works for the poster. Instead,
the commission was handed
wholesale to professional design
houses. Without the necessity
of having use a particular artist's
work, designers settled on familiar
themes – the sun, ice creams,
parks and the ever-dependable
home of the Royal Academy,
Burlington House.

Page 81 · 2008
Design by Humphrey Ocean RA
(b. 1951)/UXB London

The theme for 2008's exhibition
was 'Man Made'. One of the
coordinators, Humphrey Ocean,
developed a design suggestive of
the Edwardian typographical style.
In 2013, reproductions of Ocean's
painting *Lord Volvo and His Estate*
(1982) appeared on billboards as
part of the Art Everywhere project,
which saw art invade spaces
usually occupied by advertising.

Page 82 · 2009
Design by Lucienne Roberts

The theme for 2009's exhibition
was 'Making Space', referenced in
this poster by two hands forming
a frame. The spaces in which
publicity was now located were
incredibly diverse, making a strong
visual identity paramount.

Page 83 · 2010
Design by Research Studios

The designers of this poster
were unaware of its predecessor,
Theo Ramos's layout for 1963.
The similarities between the two
are extraordinary considering the
intervening period of time and the
immense changes to both the Royal
Academy and the technicalities of
marketing strategy. The clever use
of tape is suggestive of unopened
crates of paintings.

Page 84 · 2011
Design by Harry Pearce, Pentagram

The 'red square' had been a part
of the Royal Academy's visual
identity since 2000. It had endured
for longer than any previous
logo, but by 2011 it was looking
a little tired and inflexible. The
Academy commissioned design
firm Pentagram to undertake a
comprehensive overhaul of the
Academy's visual brand. Before this
work was completed Harry Pearce
gave the red square a last hurrah.

Page 85 · 2012
Design by Harry Pearce, Pentagram

This poster represents the
first appearance of the Royal
Academy's new visual identity.
The typefaces are Caslon (a staple
of eighteenth-century printing)
and Akzidenz Grotesk; the latter,
recalling the letterpress posters
of the 1920s, forms the 'RA' logo.
The result is a visual language
appropriated from history but
expressed in a modernist form.
The graphic element here is taken
from the Annenberg Courtyard
exhibit by Chris Wilkinson RA: *From
Landscape to Portrait* (2012).

Page 86 · 2013
El Anatsui HON RA (b. 1944),
design by Pentagram

A strong visual identity must
retain enough flexibility to cope
with a wide spectrum of usage.
In 2013 a detail from an artwork
was introduced as the lead image
for the first time since 2005.
El Anatsui's epic wall hanging
Tsiatsia – Searching for Connection
was draped over the central
portion of Burlington House. The
work comprises many materials,
most notably liquor bottle tops.

Pages 87–88 · 2014
Güler Ates (b. 1977), Ian Davenport
(b. 1966), Michael Craig-Martin RA
(b. 1941); designed by Constanza
Gaggero

The new brand's flexibility was
tested by the variety of designs
produced for 2014's exhibition.
These posters – featuring details
of the artworks *The Shoreless
Flower*, *Pale Blue/Lilac Duplex
Colorplan*, and *Spotlight: NT at 50*
– represent current thinking on
how the Summer Exhibition can be
effectively promoted. They marry
confident and stable brand design
with bespoke graphics ('Discover
the New') while allowing the heart
of the matter, works of art, the
room they need to breathe.